Claude Cookman

WERNER
BISCHOF55

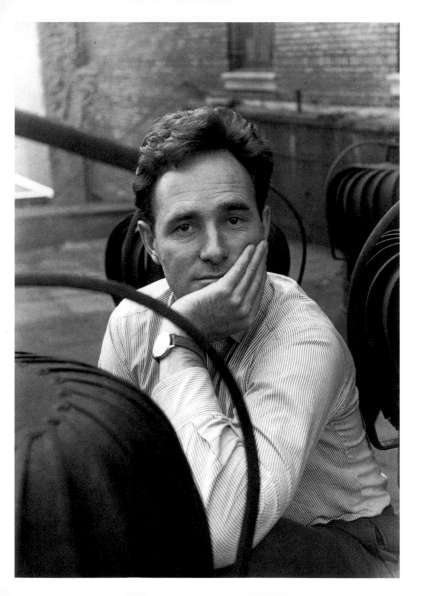

Save for an accident of history, Werner Bischof would have given the art world a body of photographs distinguished by their inventive play with light and their pure investigation of form. In his student projects and initial commissions for advertising clients in Zurich, Switzerland, he set out a broad agenda – exploration of light, natural forms, the nude, camera-less imagery – that could have sustained him throughout a career as a mature artist. The accident was World War II and its aftermath: the devastation of Europe, the disintegration of colonialism and the Cold War. Confronted by a world in turmoil, Bischof could not remain a fine art photographer. He transformed himself into an empathetic witness of humanity and its problems. While he rejected his former motifs, he never abandoned his aesthetic sensibility and extreme perfectionism, but adapted them to his new subjects: the victims of war and those trying to main-tain their traditional cultures under the assault of modern economic forces. His oeuvre contains some of the most beautiful and emotionally wrenching images ever made. Save for another accident that took his life when he was thirty-eight, he would have given the world an even broader picture of his era.

Werner Adalbert Bischof was born on 26 April 1916 into a financially comfort-able family in Zurich. He grew up in Waldshut, Germany, where his father Adalbert was transferred in order to manage a pharmacy plant. Werner's older sister Marianne recalled that their father taught them to make photograms: 'We produced photographs by placing lace and other fine objects on photo-graphic paper, which we then exposed.' Adalbert also imbued his children with a love of nature, taking them for long hikes in the mountains. From their mother, Marie Schmied, who was interested in religion and philosophy, they acquired more cerebral influences. However, Marie died suddenly in 1931, when Werner was fifteen and facing choices about his future.

From childhood, Werner's passion was art; he drew from the time he was big enough to hold a pencil. Adalbert did not support his son's desire to become a painter, wanting him to choose a more financially secure occupation. After studying for a year to become a teacher, Werner persuaded his father to let him transfer to the Zurich School of Applied Arts, where he could combine art with commerce. In the spring of 1933, he began studying photography. In his unpublished memoirs, Bischof explained his decision: 'The commercial arts course at the School of Applied Arts was full, so I decided to try photography. The endless possibilities of the new medium, the camera, fascinated me.'

Berlin and Paris were the competing centres of European photography in the 1930s. Bischof's teacher Hans Finsler was involved in the New Vision movement in Berlin, and helped organize its seminal 1929 'Film und Foto' exhibition. Among the exhibitors were Karl Blossfeldt and László Moholy-Nagy, whose work clearly influenced Bischof. Blossfeldt's extreme close-ups of plants revealed the architectural beauty of natural forms. This subject appealed to Bischof, who loved to wander in the woods, far from people: 'The animals, the plants, the wonder of growth, that was my world,' he wrote. His close-up of a Virginia creeper (page 17) shows how completely he internalized Blossfeldt's insights.

Moholy-Nagy was the champion of New Vision photography. The old vision was Pictorialism, which flourished from the 1890s to the 1910s. Modernist photo-graphers rejected Pictorialism's soft focus and tonalist effects. They insisted on purity – exploring the medium's own unique capabilities instead of imitating other arts. Moholy-Nagy, a Hungarian who taught at the influential Bauhaus School of Design, promoted photography as the quintessential modern art that would displace easel painting. He described himself as a painter with light.

Finsler linked his student directly with Moholy, calling Bischof 'a pure photographer in the basic sense of the term: he writes with light.' In his early photographs, Bischof projected light into darkened space, studied its reflections on mercury, and used it to reveal form: a latticework of light and shadow defines the curves of a nude; low raking light sets shells into relief; intense backlighting forms a halo around a fashion model. Moholy also championed the photogram, the same camera-less process that Werner and Marianne had played with as children. As an adult, Bischof continued making photograms, but they too were clear explorations of form, not puzzles or surrealistic accidents. Reflecting on his first decade of photographing, Bischof wrote in 1944, 'I learn to see (eggs, plants, objects as they are).' His dedication to revealing form in unexpected ways aligned him with the New Vision movement, a major current animating European art between the wars.

After graduation and military training in 1936, Bischof opened a studio as a graphic artist and photographer. Alfred Willimann, a former instructor, helped him secure assignments from advertising agencies and also reinforced Bischof's perfectionism — the conviction that the result he envisioned was worth the most painstaking efforts. In one example, Bischof spent countless hours cutting, sanding and polishing snail shells to achieve the translucent effect he wanted for a nature study. Having mastered New Vision photography Bischof became intrigued by the surrealism of Man Ray, an American who dominated photography in Paris between the wars. In July 1939 he travelled to Paris with plans to start a studio, but World War II intervened. He returned to Switzerland and was immediately mobilized, serving more than two years at mountainous outposts. His letters reveal his deep despair that Europe was once again destroying itself. In his loneliness, he took refuge in nature and in photographing, both on and off duty.

In late 1941 Bischof contacted Arnold Kübler, the founder of *Du*, an illustrated magazine of art and culture. Struck by the beauty of Bischof's photographs, Kübler published three in the January 1942 issue. In February he listed Bischof as a 'regular photographic contributor'. Thus began Bischof's transformation from an artist exploring light and form to a photojournalist documenting 'the face of human suffering'. Kübler encouraged him to include people in his pictures, but recalled that Bischof 'had to overcome a certain reserve' before he could develop his own view of human nature. 'Then, suddenly,' Kübler wrote, 'they were there: the pictures of people.' Bischof photographed Swiss workers, a school for the blind, and a refugee camp in Ticino, the Italian-speaking region of Switzerland. An avid reader of the pacifist Romain Rolland, he embraced human-ism and socialism as his point of view in these and subsequent stories. 'I believe it is one of our biggest tasks – the task of our life – to do everything possible to counter poverty and to build a freedom-loving future,' he wrote in 1943.

Three years later, Bischof published a book of twenty-four photographs repre-senting his first period. Twenty-three showed the old artist of light and form. The last symbolized his new direction. Taken at a camp in Ticino, it showed a refugee child whose vacant stare suggested deep psychic wounds. The war had destroyed his 'ivory tower', Bischof wrote. 'My attention focused henceforth on the face of human suffering ... At home I wistfully studied my delicate pre-war pictures, which had won me so much praise from those around me – but in my mind I saw the hundred thousand suffering people whose senses had been dulled by their daily fears and who needed our help.'

After Germany surrendered, Bischof left Switzerland to survey the devastation that nearly six years of war had inflicted on Europe. 'This is my first sight of

total destruction,' he wrote. In one town a woman appeared from a warren in the rubble and invited him to share her meagre meal. He followed her not for the food, 'but because I wanted to hear and see how people could live in these ruins'. Inside, he found a makeshift room with two beds, an electric hot plate and 'the indomitable courage needed to start from scratch'.

For the next four years, Bischof crisscrossed Europe, recording the war's aftermath. He photographed in France, Germany, Italy, the Netherlands, Poland, Hungary, Romania and Greece. His pictures tell a complex story. Many emphasize physical ruins, from the burned-out hulk of the Reichstag, to piles of bricks and stones in dozens of cities. Some are symbolic: a soldier's helmet ripped with holes lies in a mud puddle in front of the bombed Reichstag. Others express irony: children playing with toy guns. Some are poignant: wilted blossoms ring the base of a slender wooden cross bearing a typewritten tribute to the deceased, somebody's beloved mother. Most of Bischof's postwar pictures, however, demonstrate the theme he discovered on his first trip: indomitable human courage. In Monte Cassino, a woman dressed in black carries two large stones on her head for her new home. In Freiburg im Breisgau, a man has dressed in jodhpurs, riding boots, a sports jacket and a dapper hat, his jaunty outfit seems a shield against the rubble that surrounds him. In Ziros, Greece, men in tattered trousers raise the framework of a centre for war orphans.

Bischof's photographs of children are equally complex. He celebrated their resilience in pictures of girls skipping in a ceiling-less church and children playing ring-a-ring o' roses amid ruined buildings. But he also memorialized their trauma in images of their blank stares and silent tears. Bischof chose children

deliberately. Whatever the culpability of their nations' leaders, children were innocent victims of the war. Furthermore, their future, threatened by nuclear conflagration, seemed bleaker than their present. Conscious of the Cold War arms race, Bischof wrote: 'We have the East on one side and the West on the other – both powers with enormous problems of all kinds. If I can demonstrate this in and with the children, I will have created a purely social and at the same time European work.' Bischof's European photographs appeared in several issues of *Du*, two of which (May 1946 and June 1949) featured more than fifty each.

In July 1946, while passing through Italy, Bischof met Rösli Mandel, the daughter of Hungarian exiles living in Zurich. She was on her way to Rimini, to work in a children's home. Werner's travels kept them in separate spheres over the next few years, but they continued their courtship through letters and occasional reunions. On 8 December 1949 they married in Zurich. Rösli changed not only her surname, but also took a new first name – Rosellina – in memory of her three years in Italy. Their first son, Marco, was born the following year.

Bischof's career was expanding on several fronts. He produced 'How We Help', a large touring exhibition for Schweizer Spende, the Swiss branch of the Red Cross, which had underwritten some of his travels. His reports in *Du* caught the attention of *Life* magazine, which assigned him to cover such events as the winter Olympics and the coronation of Elizabeth II. *Life* also published eighteen of his photographs from eastern Europe, but gave them a slant that distressed him. The text, captions and headline, 'Iron Curtain Countries', reduced his pictures to illustrations for the magazine's conservative political stance. Bischof pronounced the text 'really terrible'.

Bischof's judgement typified his relations with the magazine world. He was determined to expose social injustices and to prick the public's conscience in order to create the political will to correct them. Illustrated magazines offered the greatest access to public awareness, but the collaboration was never easy. Bischof wanted the strongest and clearest statement of a problem as he envisioned it. The magazines, meanwhile, wanted to make a profit. Kübler acknowledged this tension, writing: 'He took it badly when editorial offices or other customers touched up the unpleasant truth in his pictures, toned it down for less admirable reasons, trivialized it to pander to readers.' Bischof chafed under the indignities that the editing process inflicted on his pictures and his point of view: distorted captions and texts that gave his photographs a false interpretation; bad crops and flipped pictures; shooting scripts that called for political slants and melodramatic images. Such constraints eventually caused him to repudiate his status as a reporter, but he continued to photograph for the magazines that gave him a mass audience. He was always interested in exhibitions and books, but they reached hundreds where the magazines reached millions. In addition to *Du* and *Life*, his work was published in *Picture Post* and *Illustrated* in England; *Epoca* in Italy; *Camera*, *Die Woche* and *Sie und Er* in Switzerland; *Paris Match* in France; and *Holiday*, *Popular Photography*, *Infinity*, *Photography* and *The New York Times Magazine* in the US.

In 1948 Magnum Photos began recruiting Bischof. A co-operative owned by photographers, Magnum insisted that clients who assigned a photographer were buying only the one-time publication rights, not the negatives. This principle let photographers build a stock of images for secondary sales. Now more than fifty years old, Magnum is a prestigious agency. In 1948, when it tried to recruit Bischof, it had been in existence for barely a year and was struggling

financially. One of its five founders had quit, leaving Robert Capa, Henri Cartier-Bresson, David Seymour (Chim) and George Rodger as partners. The first three had been friends since the early 1930s, when – like many young European artists, intellectuals and journalists – they were engaged on the left in opposition to Fascism. 'What is important to me is that they are all sound people and socialist-inspired,' Bischof wrote to Rosellina. 'They are free people, too independent to tie themselves to one magazine.' Despite his admiration, he did not join Magnum until November 1949, when it offered to make him a shareholder on a par with its founding partners.

Whatever his conflicts with the business of photojournalism, Bischof had clearly broken with his early aestheticism. After photographing a chapel in Edinburgh, he wrote: 'Beautiful to look at, but wrestling for hours with lights and tripods to get these "dead" things simply doesn't appeal to me anymore. I'd far rather stand around a railway station, amidst the bustle, the coming and going.' He soon experienced a place more lively still. In February 1951 he departed for India and remained in the Far East for almost two years. While he covered specific topics for several magazines, on his own he developed a personal theme that would occupy him for the rest of his career. As Westernization flooded the former colonial countries, Bischof felt the pressures on ordinary people. He wanted to record their struggle to maintain their traditional cultures against the onslaught of modern economic forces. Repeatedly, in India, Japan, Korea, Hong Kong, Indochina, Mexico and Peru, he left the cities to seek out towns and villages still unspoiled by the encroachment of modernism.

Soon after arriving in India Bischof produced a major report for *Life* on a famine devastating the state of Bihar. At first he reacted to the Indians' plight

with reticence, but the emaciated victims in the village of Dighiar rekindled his desire to witness. 'I saw these starving women through the lens of my Rolleiflex,' he wrote, 'and it was the first time I used the camera without inhibition.' In a letter to Bischof, Edward Steichen, Director of Photography at the Museum of Modern Art in New York, lauded the political impact of his pictures in *Life*: 'I wish they could be on the desks of senators and congressmen when they wrangle about the political aspects of sending wheat to starving people.' Bischof was personally torn, however. He wanted to show the beauty in people's lives, to produce positive stories that were ignored by a press interested only in crisis. But he refused to ignore the turmoil, writing, 'I believe we have a duty to tackle problems from our point of view with great concentration and judgement, and shape the picture of our generation.'

In July 1951 Bischof arrived in Japan, but almost immediately left for Korea to cover the evacuation of a village. He took as his theme the question, 'What happens to the civilian population in the battle zone?' On two subsequent trips he photographed a camp for North Korean and Chinese prisoners of war, and war orphans in the cities. In a world where many were blinded by racism, he portrayed these Asian children as equals with the European orphans he had photographed a few years earlier.

Back in Tokyo, he received a cable from Capa requesting a quick story on the American influence on Japan. Bischof liked the idea, but not the rush. 'I always become too engrossed in the material everywhere, and that is not journalistic,' he replied. He considered himself different from the journalists at the Correspondents Club who covered Japan through Western eyes. He wanted to feel Japan as an insider. 'A big story never pays,' he acknowledged in another

letter. But he insisted he would never stop, 'because these big essays give me a sense of what a country is really like'. At his own pace, he experienced Kyoto's temples and gardens, the victims of Hiroshima, the Emperor, Shinto priests, sumo wrestlers and striptease dancers. As part of Magnum's 'Generation X' project, he photographed two students caught in the contradictions of change: Mitschiko Jinuma, who followed traditional customs at home but dressed as a Western co-ed at her fashion-design school, and Goro Suma, a law student at Kyoto University who distributed political manifestos but also found time to play baseball.

In 1952, when Vietnam was still called Indochina and the war still belonged to France, *Paris Match* assigned Bischof to cover the Foreign Legion's attempt to hold on to this vestige of France's colonial empire. He hated the editor's shooting script, which called for 'Heroic shots of isolated post with all elements representative of France: flag, photos, letters, radio, etc. Isolation and bravery at remote outpost'. But he delivered their request. Personally, he was captivated by the beauty of the people and their simple life. He lived for a time in a village called Barau, which struck him 'like an oasis in the midst of the cruel war. Here are birth, life, natural death.' The war and his friction with the magazines – among other problems, he could not find a publisher for his Barau story – brought him doubt and despondency. 'I've had enough,' he wrote to Rosellina. 'This story-chasing has become hard to take – not physically, but mentally. The work here no longer brings the joy of discoveries; what counts more than anything here is material value, money-making, fabricating stories to make things interesting. I detest this kind of sensation mongering … I've been prostituting myself, but now I've had enough. Deep inside me I still am – and always will be – an artist.'

Bischof arrived home in Zurich in December 1952. As he edited his work of the past two years, much of which he had not seen, he began to recover from his disillusionment. He turned his new work into an exhibition and a special issue of *Du*. He visited Paris and met Cartier-Bresson, his Magnum colleague and artistic hero. He learned that Cartier-Bresson, who had also photographed extensively in Asia, shared many of his concerns. Most significantly, he began planning his next campaign. Continuing his theme of threatened native cultures, he decided to photograph the indigenous peoples along the Pan-American Highway through Central and South America. In September 1953 he sailed for New York.

New York provoked contradictory reactions in Bischof. He described its non-stop energy as 'exciting, fascinating, like a femme fatale'. But he was equally struck by its 'emptiness of daily life, the dryness of human relations'. In the sea of faces on the Manhattan streets he saw 'the successful, the disillusioned, the strugglers, the ossified, those who have given in and those who still have a spark in them, those who would like to leave but cannot, those who slowly decay in the big, wonderful, heartless and ruthless world of dollars'. In his photographs, the city feels oppressive and impersonal. The people are anonymous, scurrying across a damp street, blurred in a store window, or trapped in a tangle of construction rods.

In New York, Bischof met some of the magazine editors who handled his work, and got acquainted with the Magnum staff. He also met Steichen, who was planning the 'Family of Man' exhibition, which would include several of Bischof's photographs when it opened two years later. To raise funds for his South American trip he photographed assignments for *Fortune* magazine

and Standard Oil. Eventually, he secured underwriting from Schlumberger, a multinational oil corporation. In February 1954 Bischof and Rosellina outfitted a car and drove from New York to Mexico City. Crossing into Mexico, he identified a simplicity and genuineness in this country. He described 'driving very slowly and savouring the gorges, plateaux and tropical forests', adding, 'We try to avoid all the tourist sights and often spend the night in villages and haciendas.' After accompanying her husband on several excursions outside Mexico City, Rosellina, who was pregnant with their second son, flew home to Zurich.

Bischof covered assignments in Mexico, Panama and Peru. In Chile, he photographed a language teacher for 'Women Today', a Magnum project portraying women around the world who were juggling family duties with professional careers. Soon, his doubts about magazine photojournalism returned. In a letter to Rosellina written from Lima on his thirty-eighth birthday, he lamented their separation, declaring, 'I cannot go on like this.' He missed the Far East, which he considered beautiful in comparison to Lima's neighbourhoods. Of his work he wrote: 'I also think a lot about my great plans, the equipment – whether there really is any point to all this effort and expense for the few shots that might be interesting.' He concluded with a French expression, *On verra!* (We'll see!).

Bischof's outlook improved when he left the city and encountered the people of Pisac, with their strong faces, colourful capes and llama caravans. En route to Cuzco, he took one of his most famous photographs: a youth playing a wooden flute as he strides along a dirt road. At Machu Picchu the Inca ruins delighted Bischof. In 'the play of colours, the flecks of light on their ancient walls' he saw touches of artists like Paul Klee and Georges Braque. Back in Lima, he encountered an acquaintance from Zurich, Ali de Szepessy. The geologist had gained

access to a promising gold mine on the Amazon side of the Andes. Such mines were rarely photographed, but Szepessy invited Bischof to come on the trip to document this site. On 16 May they phoned to report car trouble, but it was a Sunday and they could get no help. A few hours later their car plunged into a deep gorge, killing Bischof, Szepessy and their driver.

Nine days later Bischof's colleague Robert Capa was killed when he stepped on a mine while covering French soldiers in Indochina. That same day Rosellina gave birth to their second son, Daniel Werner Bischof. Until her death in 1986 Rosellina maintained ties with Magnum, directing its Zurich office for many years. She supported the Concerned Photographers movement, launched by Cornell Capa to promote the work of his brother Robert, Bischof and others trying to make the world better with their photographs. She was a founding member of the Swiss Foundation for Photography, and worked to keep Bischof's photographic legacy alive through exhibitions and books. Since her death, that role has fallen to their son, Marco.

Werner Bischof's legacy includes hundreds of photographs distinguished by their beauty and their empathetic portrayal of the human condition. From the face of human sadness to the resilience of the human spirit, from the ravages of war and famine to the simple authenticity of traditional cultures, Bischof pictured his era with courage and love. Combining his artistic sensibility with the European tradition of the journalist as an engaged witness, Bischof expressed an exacting standard for photography, one that he achieved in his own images: 'Only work done in depth, with total commitment, and fought for with the whole heart, can have any value.'

Virginia Creeper, Zurich, Switzerland, 1935. Strong side-lighting and a black background emphasize the sinuous tendrils, fuzzy texture and complex forms of this Virginia creeper. Taken during Bischof's student days, the photograph shows the influence of such New Vision photographers as Karl Blossfeldt, who sought to reveal in fresh ways things so familiar they might otherwise be overlooked.

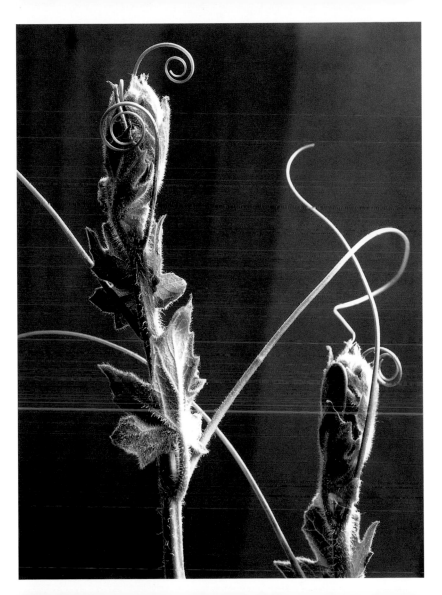

Nude Back, Zurich, Switzerland, 1937. Bischof's mastery of lighting transforms the model's back into a study in tonality. Between the large areas of deep black and the small patches of intense highlights lies a controlled modulation of greys. Bischof also creates a spatial depth that counters expectations. The black on the left, which should read as background, instead exists as a plane in front of the model, so that she seems to float in front of the plane on the right.

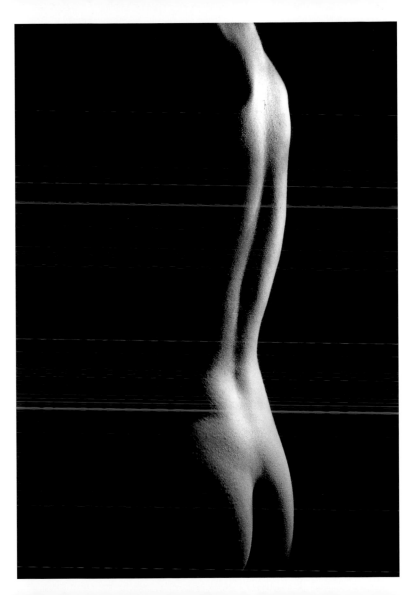

Dandelion, Zurich, Switzerland, 1937. From his boyhood hikes in the mountains with his father and sister, to the depressing days of World War II when he sought solace in the countryside, Bischof was inspired and sustained by nature. In this extreme close-up, he invites the viewer to pay attention to what is typically ignored as a common weed. As the dandelion propagates its seeds, light turns their shafts into spokes and defines the texture and spheroid form of its core.

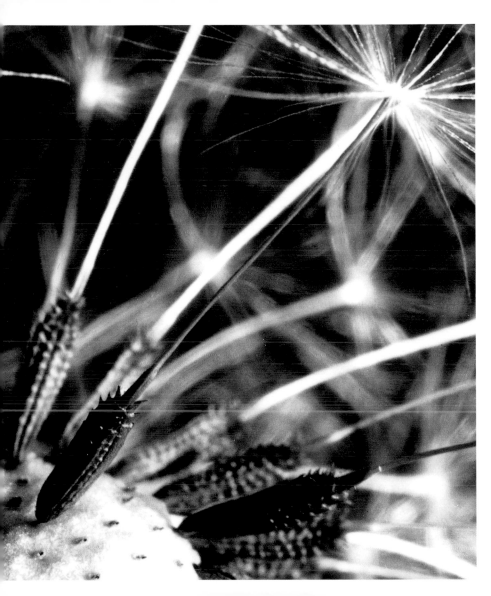

Torso, Zurich, Switzerland, 1941. Bischof projects the flat pattern of a piece of lace across the undulations of a woman's torso. This synthesis allows the viewer to experience both in a fresh way. During the late 1930s Bischof became interested in Man Ray's Surrealism, and he probably knew Ray's similar photograph of 1931, *Return to Reason*, in which window light passing through curtains defines the form of the model.

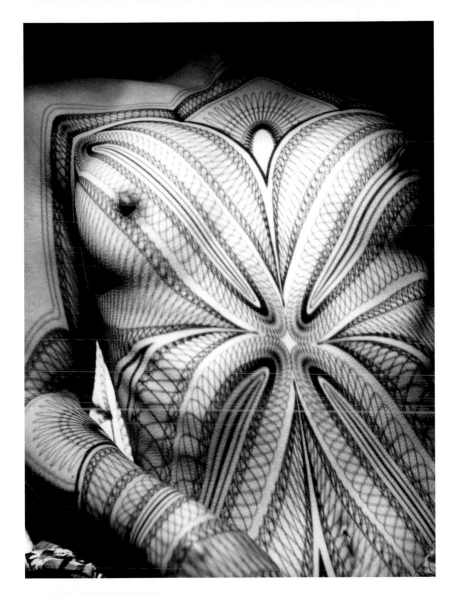

Argonauta, Zurich, Switzerland, 1941. Shells were a recurring subject during Bischof's period as an advertising photographer. What looks like a beach scene discovered in nature is in fact an example of his extreme perfectionism in setting up a scene. This studio still life has been carefully arranged and lit so that the shell's spikes appear white against their background, while their shadows cast into the foreground look black against the sand.

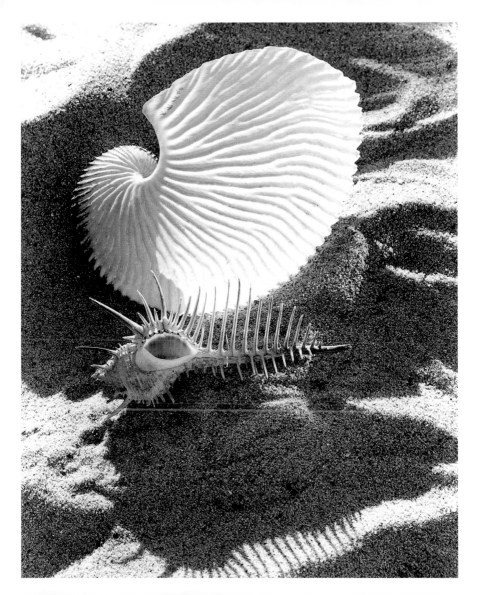

Sleeping Beauty, Zurich, Switzerland, 1941. As in *Torso* (page 23), Bischof projects a pattern of light that plays over the model, revealing her form, but in this photograph the effect is very different. Instead of the sensuality suggested by the lace and torso, a feeling of vulnerability and tenderness predominates. The viewer is invited to imagine this young woman's dreams.

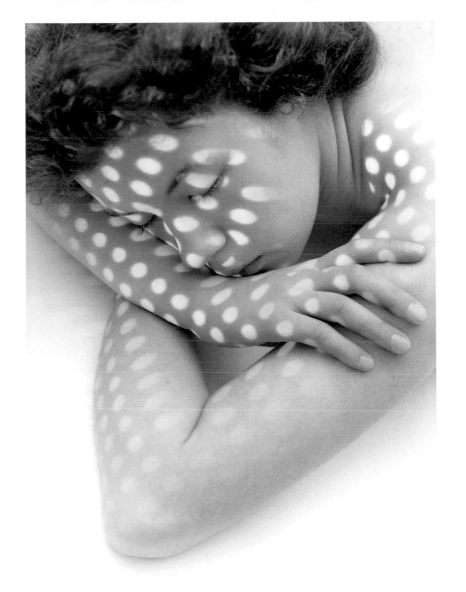

Looking for Work, Rouen, France, 1945. Under a pall of smoke, unemployed men gather at a railroad yard, hoping for a day's work. After World War II the reconstruction of the economies in European countries was a vitally important challenge. As the jubilation of liberation faded, individuals faced the personal need to support their families while governments dealt with the collective imperative to prevent desperate citizens from turning to the extremes of Fascism on the right or Communism on the left.

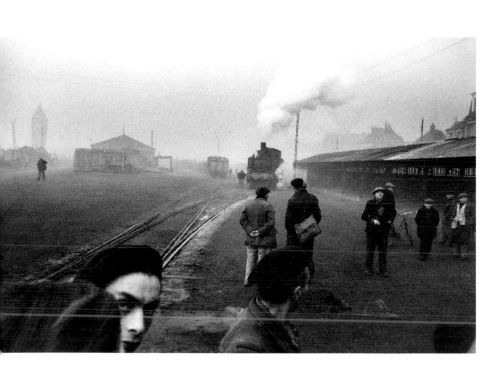

The Reichstag, Berlin, Germany, 1946. The burned-out hulks of cars and trucks ring the Reichstag, the lower house of the German parliament. Even with its dome shattered by bombing, the building's distinctive profile remains recognizable. On a human scale, a soldier's helmet, ripped by a volley of shrapnel that must have proved fatal, lies rusting in a puddle. Bischof took this photograph from a position in front of the Swiss Embassy.

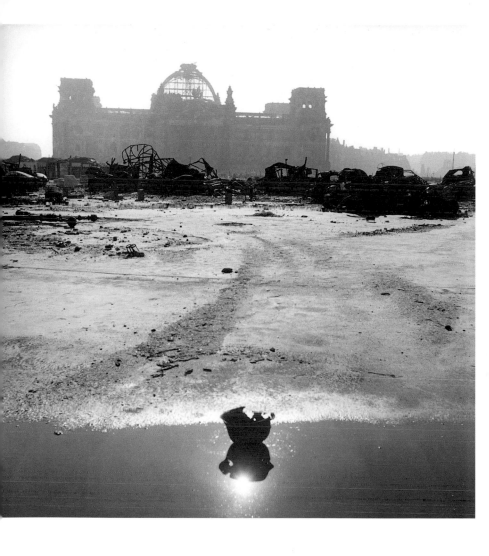

Collecting Wood in Front of the Reichstag, Berlin, Germany, 1946. Bischof was repeatedly struck by the 'indomitable courage' of people forced to begin their lives again in the face of seemingly overwhelming devastation. Ignoring their ruined Capitol, two women and a boy focus on filling their burlap sacks and a pram with wood to burn or perhaps to sell.

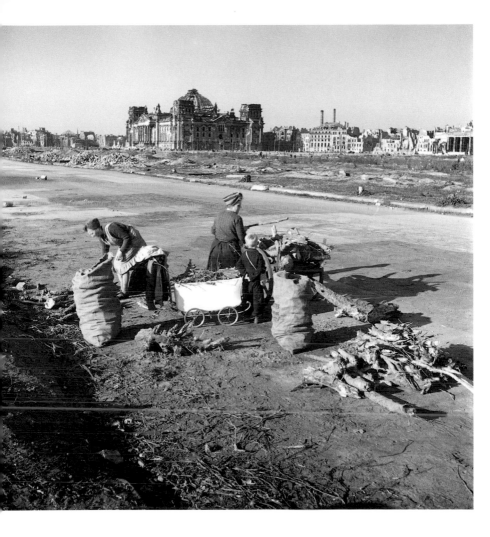

Puszta Inn, Hungary, 1947. A round of wine and beer spurs conviviality among small-town friends who have known each other all their lives. In this inn frequented by farmers, one carafe has already been drained, while one and a half remain, and nobody seems in a hurry to move on. The photograph was one of several by Bischof that Edward Steichen, Director of Photography at the Museum of Modern Art in New York, included in his 1955 'Family o Man' exhibition.

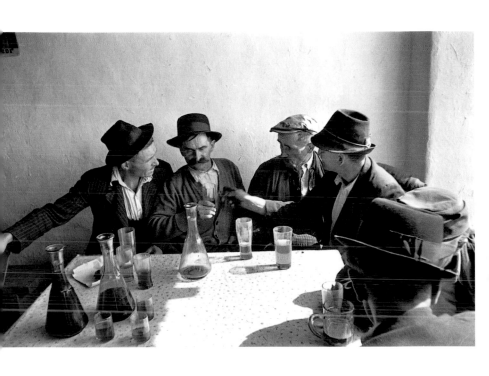

Precious Eggs, Hungary, 1947. Few of Bischof's subjects confront the camera directly, but this boy seems to gaze through the lens into the viewer's consciousness. Out on a snowy morning without gloves or a proper coat, he cradles with tenderness and pride two eggs, the prize of his labours.

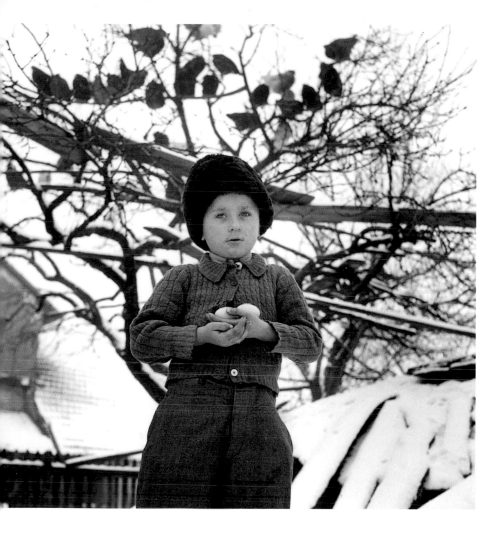

Peloponnese, Greece, 1947. After World War II Bischof spent several years documenting the physical destruction of Europe's cities and towns. This landscape, looking across a tidal pool to distant mountains, might seem at first to be an attempt to find a respite from the devastation. Its meaning grows deeper however, when one recalls what Bischof surely knew, that in ancient times the Athenians and Spartans fought a fierce war in this area that lasted for more than twenty-five years.

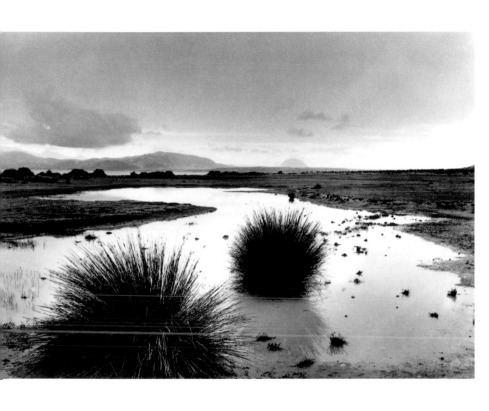

'No alla Guerra', Italy, 1947. In two-foot-high letters, this graffito proclaims the sentiments of a war-weary people. Photographing the words themselves would have made a strong statement, but Bischof intensifies their message by including three children, innocent victims of a past war and potentially of a future one. He deliberately chooses children to heighten the viewer's understanding of the postwar rivalry between the two superpowers. 'We have the East on one side and the West on the other – both powers with enormous problems of all kinds,' he wrote. 'If I can demonstrate this in and with the children, I will have created a purely social and at the same time European work.'

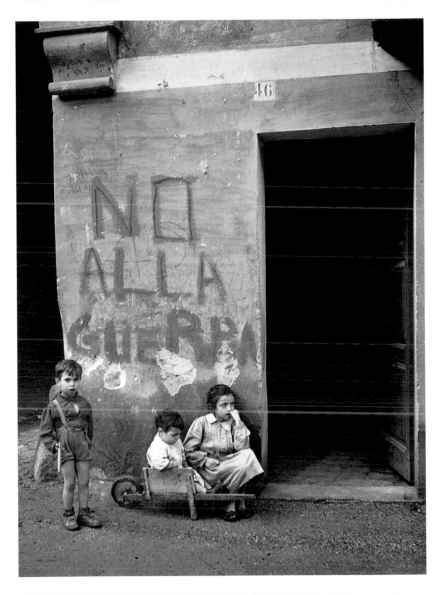

Good Dog, Iglesias, Italy, 1947. Bischof's Magnum colleague Henri Cartier-Bresson claimed that a good photograph should ask questions. This one demands to know: how long has this dog been sitting to attention?

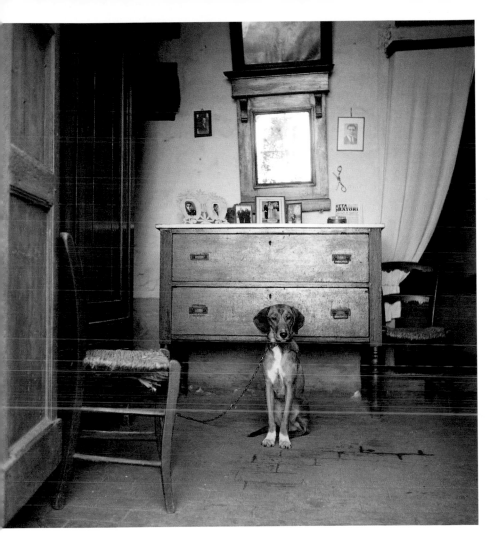

Mamma … Mi Piace il Ritmo, Naples, Italy, 1947. Enterprising boys offer black-market cigarettes to passersby, while a young woman, who is also a street vendor, seems more interested in the day's news than making a sale. The headline on the single-sheet journal reads 'Mamma … I like the rhythm'.

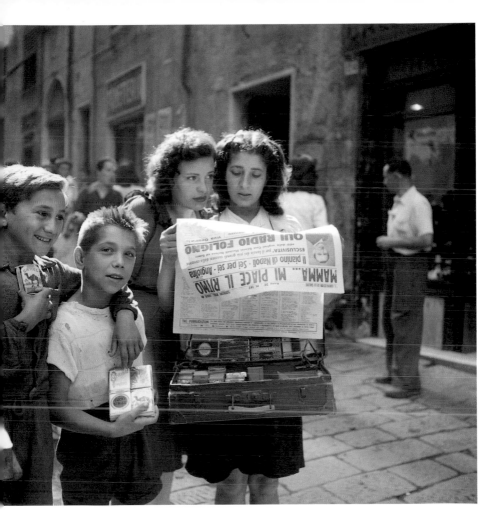

Red Cross Train, Budapest, Hungary, 1947. A large tear collects under each eye of the girl on the right as she and her companions – orphans under the care of the Red Cross – stare into an uncertain future. Children like these were often sent to Switzerland for three months of recuperation, only to return to the shocking devastation of their own country.

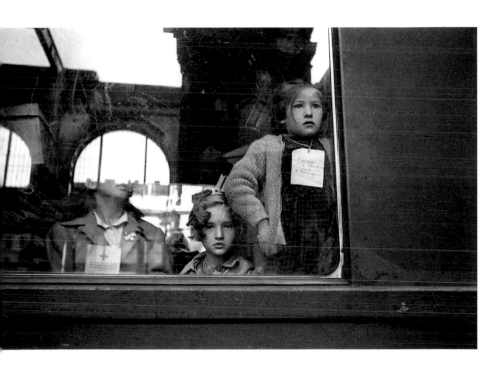

Penguin Promenade, Edinburgh, Scotland, 1950. By mid-century, Bischof was receiving regular assignments from the major picture magazines. The London publication *Illustrated* sent him to Edinburgh to do a story on the weekly parade of penguins through the busy streets. The city's zoo staged the event to promote attendance. Bischof found that the best angle from which to tell the story was from below, looking up. He favoured the Rolleiflex camera, which had a top viewer that made such low angles easy to manage.

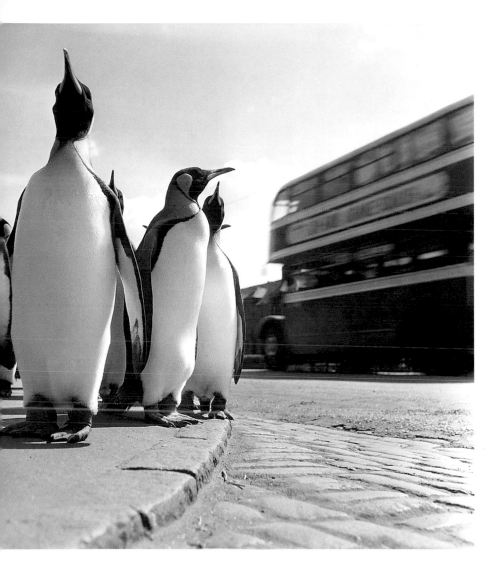

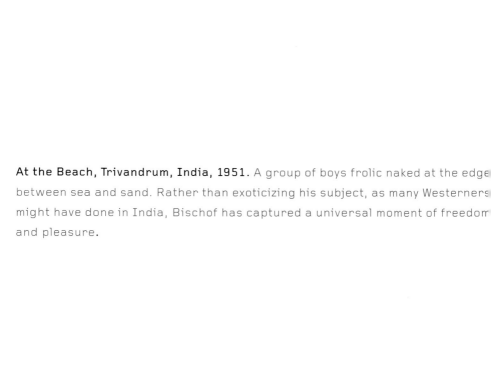

At the Beach, Trivandrum, India, 1951. A group of boys frolic naked at the edge between sea and sand. Rather than exoticizing his subject, as many Westerners might have done in India, Bischof has captured a universal moment of freedom and pleasure.

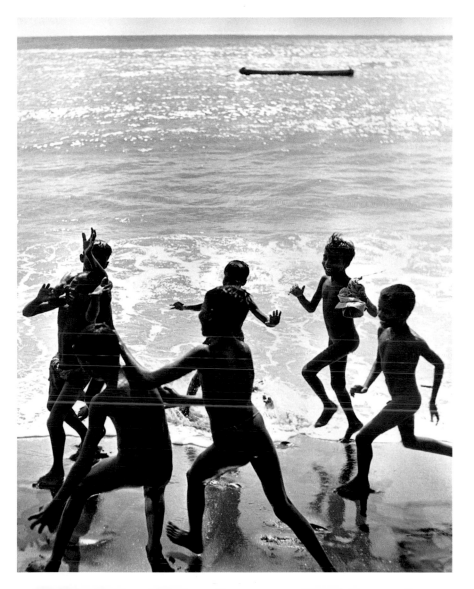

Anjali Hora, Bombay, India, 1951. Kneeling on her bed, Anjali Hora applies makeup with the help of a mirror, out of frame on the left. In front of her is a chain of fresh jasmine blossoms, which she will use to tie up her long hair. This photograph is part of a story that Bischof produced on the temple dancer for a Magnum project called 'Generation X'. Under the headline 'Youth and the World' *Holiday* magazine introduced its version of the 'Generation X' material as follows: 'This is a story about people. This is a story about tomorrow. This is an attempt to assay the future of the world through the individuals who will make most of its history for the next fifty years – the young people of today.'

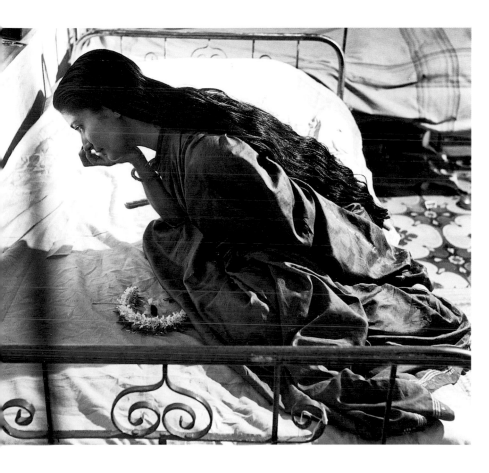

In Front of the Steel Works, Jamshedpur, India, 1951. Two worlds and two ways of life are juxtaposed in a single frame. Bischof was concerned about the encroachment of Westernization and industrialization on traditional cultures. In this case, a steel mill forms a grimy backdrop for three women carrying bundles on their heads.

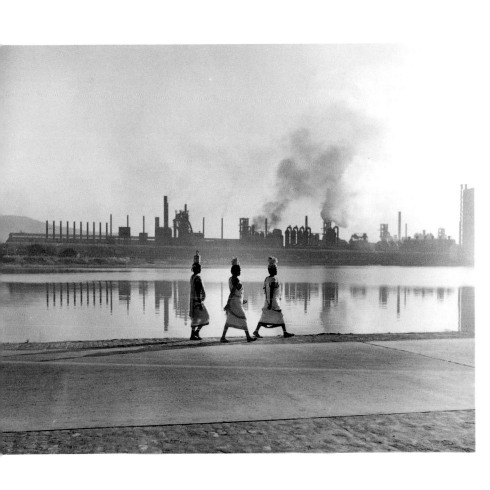

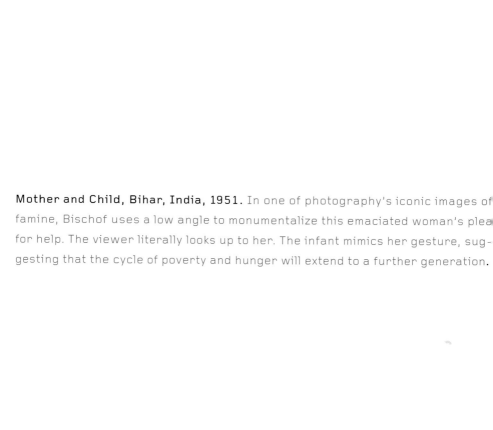

Mother and Child, Bihar, India, 1951. In one of photography's iconic images of famine, Bischof uses a low angle to monumentalize this emaciated woman's plea for help. The viewer literally looks up to her. The infant mimics her gesture, suggesting that the cycle of poverty and hunger will extend to a further generation.

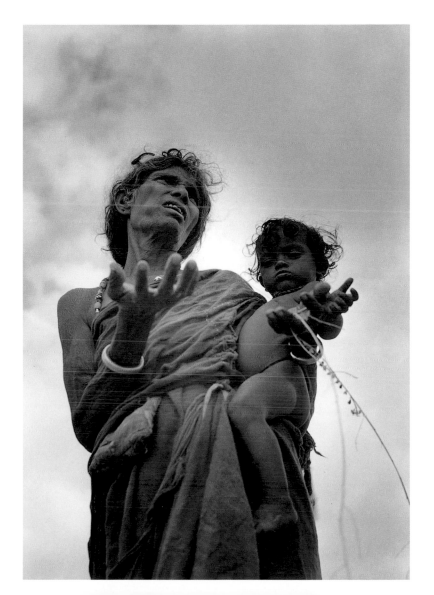

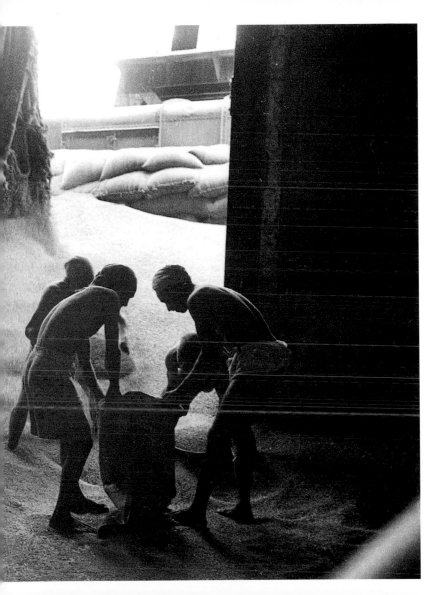

(previous page) In the Docks, Calcutta, India, 1951. Although the United States sent grain to help relieve the famine that afflicted India in 1951, distribution problems slowed the process of getting the food to victims. This photograph, which was prominently displayed in Bischof's essay in *Life*, shows workers sacking and unloading grain by hand from a ship.

'Baba murita ...', Bihar, India, 1951. 'Baba murita' (Sir, we are dying), one of these famine victims told the *Life* writer who accompanied Bischof through the Darbhanga district of Bihar. In an example of how committed photographers can make a difference with their coverage of social problems, Bischof's photographs played a role in the deliberations of the US Congress on continuing aid to India.

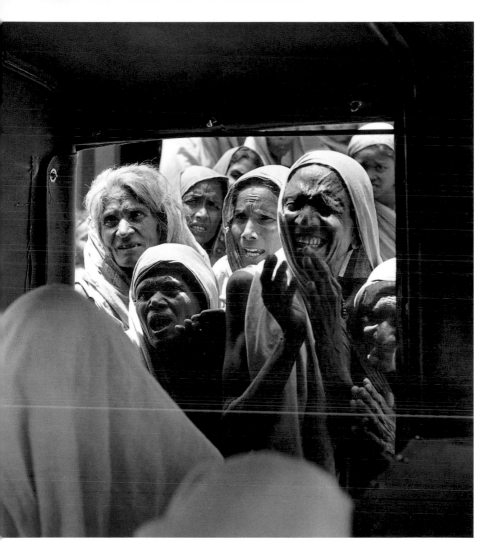

Tea Time, Sikkim, 1951. An experienced mountaineer, Bischof arranged to accompany a caravan along the old trade route between India and Tibet. It began in Gangtok, the capital of Sikkim, which is now a tiny state in the north-east of India between Nepal, Bhutan and China. The caravan stopped for refreshment at this lodge in Kapup. Bischof used artificial lighting to bring out the rough texture of the wall and to emphasize the pictographs across its top. They were probably intended to ward off evil.

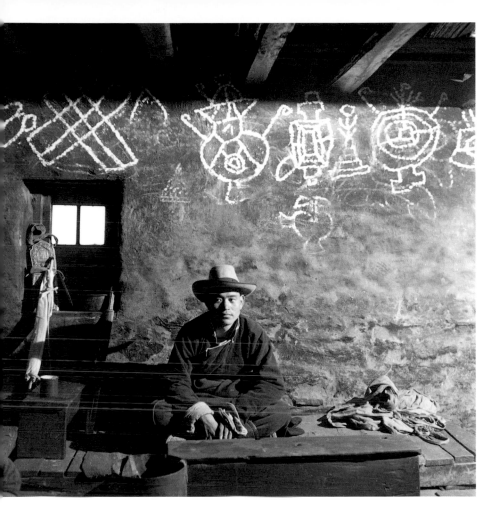

On the Jelep La Pass, between Sikkim and Tibet, 1951. For political reasons, Bischof could not enter Tibet, but he travelled as far as the 15,000-foot-high Jelep La Pass that cuts through the Chola mountain range bounding Sikkim on the east. Choosing an exposure that transforms this man's face into a silhouette, he makes him a symbol for all the caravan drovers who have struggled through this rugged terrain near the top of the world. On the horizon in the background is Chomo Lhari, which peaks at over 23,700 feet.

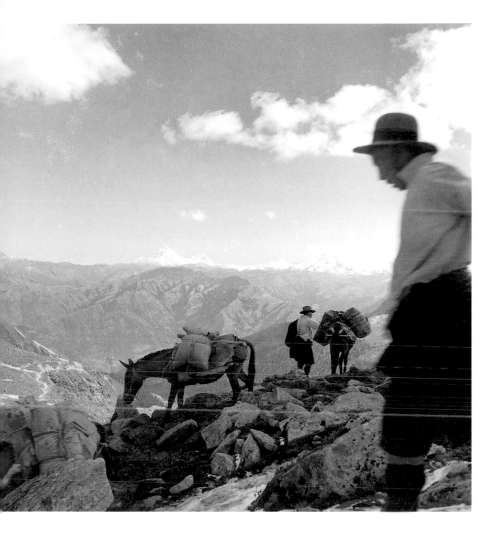

Precious Drink, Sikkim, 1951. Along the trek, Bischof recorded this young woman carrying a brimming glass of tea. That it is served in a glass suggest it is Indian-style tea, laced with milk and sugar.

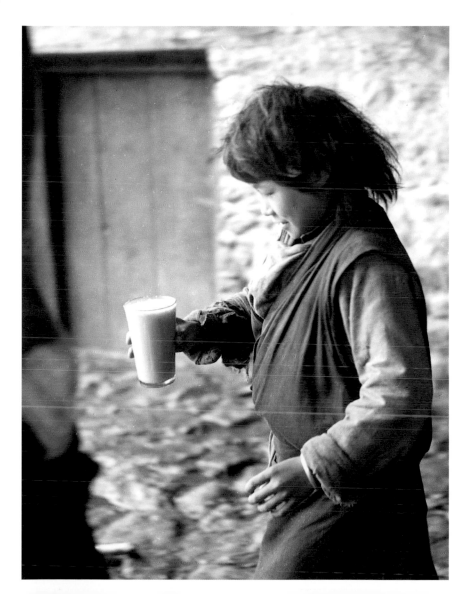

Silk Drying, Kyoto, Japan 1952. In a letter to his wife Rosellina, Bischof writes of a taxi trip to the Kyoto countryside during which he discovered silk workers 'washing long streamers of coloured silk in the river and hanging them out to dry on tall bamboo poles. Can you imagine what a wonderful sight that is?' he wrote. 'All the coloured streamers swelling and swishing in the wind, wondrous ... Naturally I couldn't just drive past, and spent an hour there.' After Japan's political capital moved to Tokyo, Kyoto remained the centre of traditional culture, such as the silk industry. These patterned fabrics would have been used for kimonos, obis and other items of Japanese women's traditional formal wear.

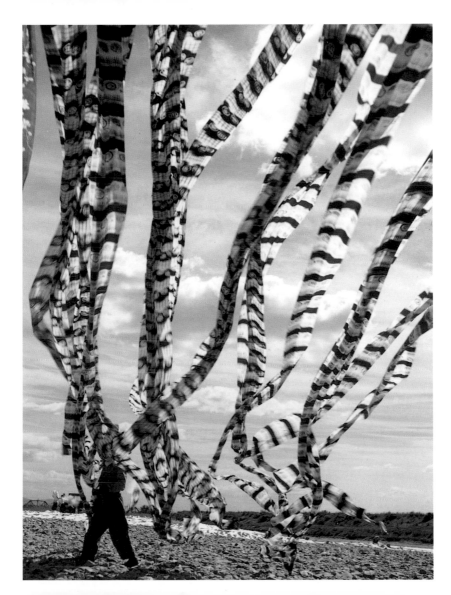

Sumo Wrestler, Japan, 1952. As part of a purification ceremony before his match, a sumo wrestler flings salt into the ring. Bischof's slow shutter speed transforms the grains into white lines, visible along the right edge of the photograph.

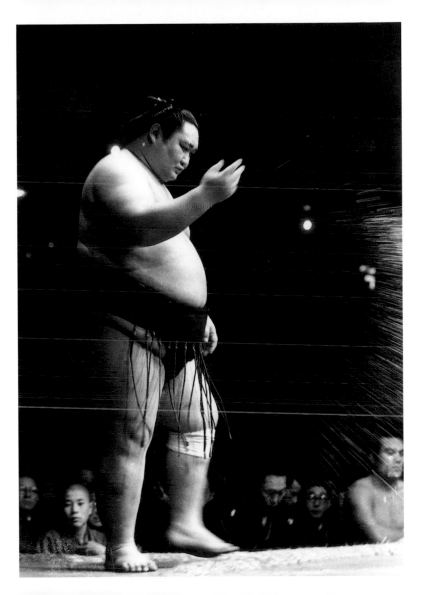

Master Sen Tantansai So-shitsu, Kyoto, Japan, 1952. Asked to do a quick story on Japan, Bischof insisted on understanding the country and its people at his own pace – as far as possible in the role of an insider rather than as an interloper. Here he reveals the simplicity and serenity of the tea ceremony, one of the anchors of traditional Japanese culture. The photograph's subject, Sen Tantansai So-shitsu, traced his lineage back fifteen generations to Sen Rikyu (1522–91), who perfected the tea ceremony.

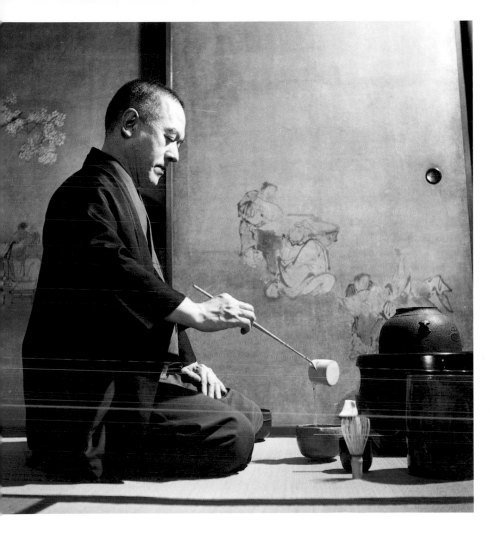

Picasso Exhibition, Tokyo, Japan, 1951. No less than the steel works a
Jamshedpur, India (page 55), this photograph captures the collision of tw
cultures. Bischof's framing positions the viewer within this group, while reveal
ing in the angled heads and leaning torsos the struggle of these young Japanes
men to comprehend Picasso's art. Both figures in this painting would hav
seemed strange, since during World War II all images of female nudity wer
suppressed, and there is no counterpart in Japanese mythology to the ancien
Greek centaur.

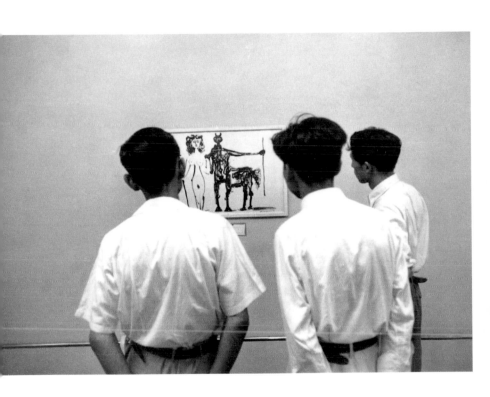

Dancer, Japan, 1952. With the occupation of Japan by American soldiers came various manifestations of the sex industry, including striptease clubs. Bischof takes the viewer backstage at such a club, showing one of the dancers putting on her makeup. In contrast to the Indian dancer Anjali Hora (page 53), who was performing the same task, Bischof shows this young woman's face fragmented by an array of mirrors.

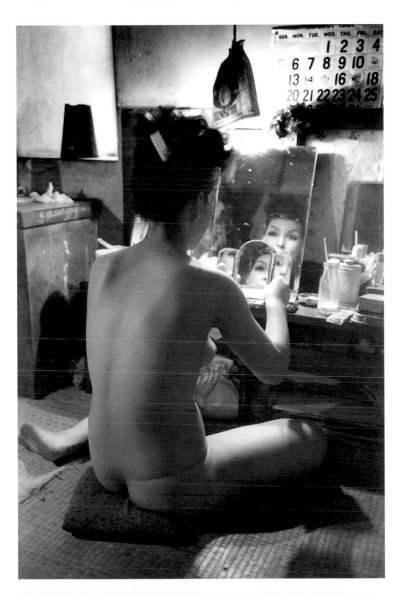

Okinawa Air Base, Japan, 1952. Like a boy pulling his toy wagon, a US Air Force member drags the tail section of a jet plane along behind him. Although Bischo rarely indulged in humour, he must have appreciated the surrealism in thi unexpected situation.

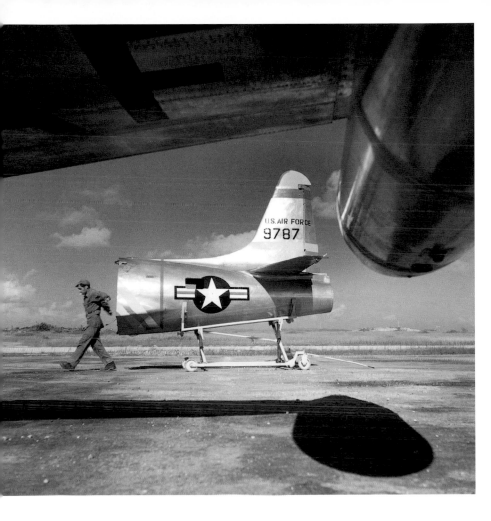

In the Garden of the Meiji Temple, Tokyo, Japan, 1952. Shinto priests shelte from a snow shower with paper umbrellas as they walk in front of a shrine ded icated to the Emperor Meiji. Surrounded by the city of Tokyo, the shrine include a large forest with more than 360 species of evergreen trees, donated b people from across Japan. Emperor Meiji, who died in 1912, is credited wit bringing Japan into the modern era. The picture's interplay of horizontal an vertical elements, its tonal nuances, its placement of directional forces — a deployed to crystallize a small, human moment — make this one of the mos beautiful photographs ever taken.

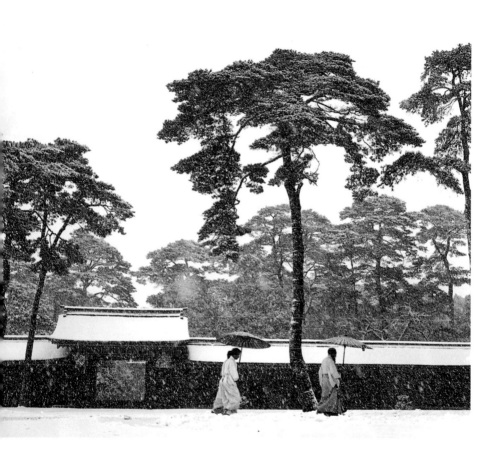

International Press Corps, South Korea, 1952. Bischof's disagreements with the magazine industry coloured his view of fellow journalists, and he referred to his colleagues in Korea as 'vultures of the battlefield'. Nonetheless, in this picture he does not ridicule the still photographers and newsreel cameramen who join him in covering the ceasefire negotiations at Kaesong. Instead he shows them intently practising their trade in the face of fatigue and shoulder-to-shoulder competition. For those interested in the history of photography, this picture offers a visual catalogue of cameras in use during the middle of the twentieth century: Speed Graphics, Rolleiflexes, Leicas and hand-wound movie cameras.

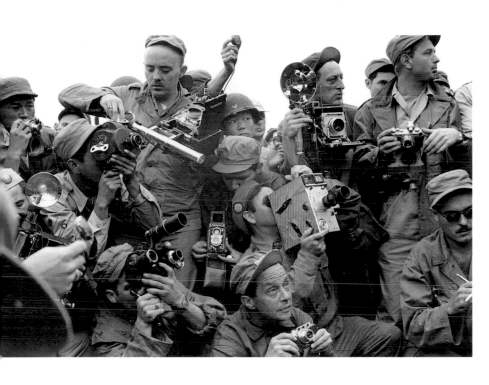

Youngest Prisoner, Koje Do, South Korea, 1952. In uniform like his older comrades, a boy of perhaps seven or eight draws his ration of soup and steaming rice at the prisoner-of-war camp. Again, Bischof uses a child – in this case in an unexpected situation – to make a point about the Cold War.

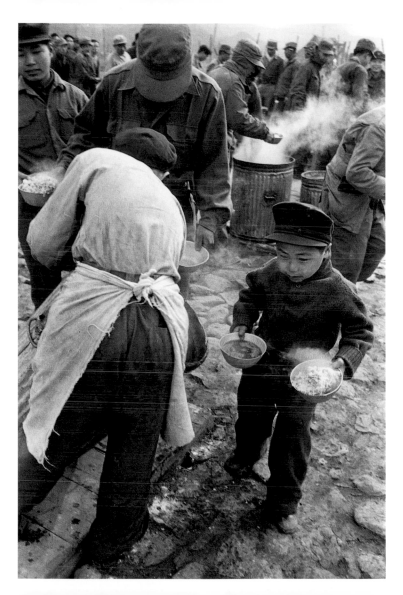

Square Dance at Re-education Camp Koje Do, South Korea, 1952. A primary objective of this camp was to teach Western lifestyle and values to Chinese and North Korean prisoners of war. Among other manifestations, this involved the adoption of Western icons, like the Statue of Liberty in the background, and learning such folk activities as square dancing. On this occasion, the prisoners have added their own indigenous dimension – the paper masks.

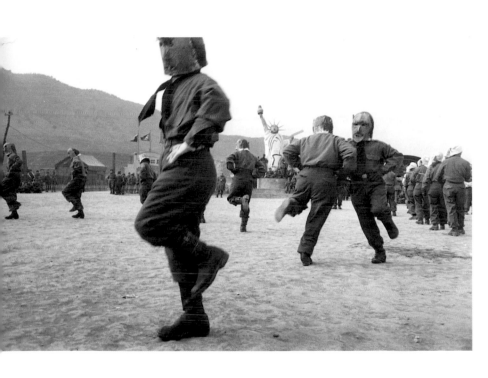

The Gang, Pusan, South Korea, 1952. Bischof encloses a trio of street orphans in a claustrophobic space that suggests their limited horizons. The boys offer three distinct expressions, but the uncertainty on the face of the boy on the right comes through strongest. In humanizing such Asian children, Bischof equates them with the European orphans that he photographed a few years earlier in the wake of World War II.

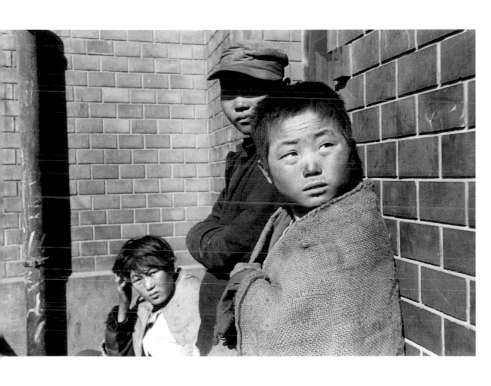

Junks, Hong Kong, 1952. Although he rejected aestheticism for its own sake Bischof never lost his artist's sensibility for a majestic scenic view. In what could have become a chaotically busy composition, he carefully arranges this group of junks below the horizon, balancing their sharp sails with the towering clouds.

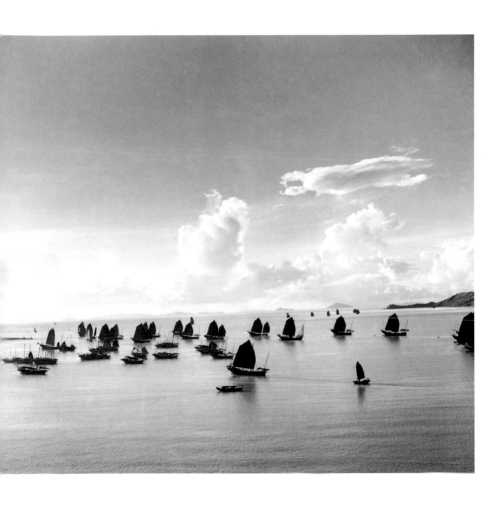

Heat, Hong Kong, 1952. Bischof's visit to Hong Kong coincided with an almost unbearable heat wave. For many, such as this woman and child, the only escape was to sleep through the hot afternoons.

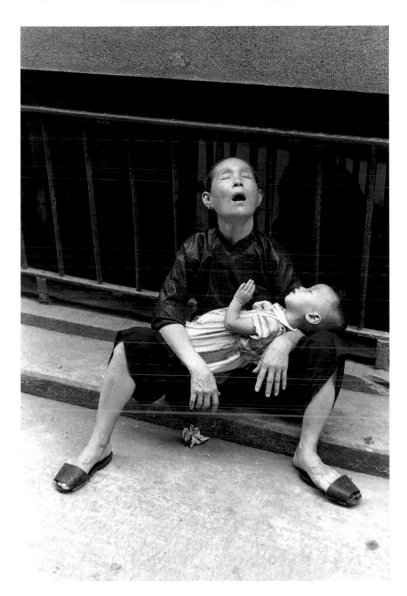

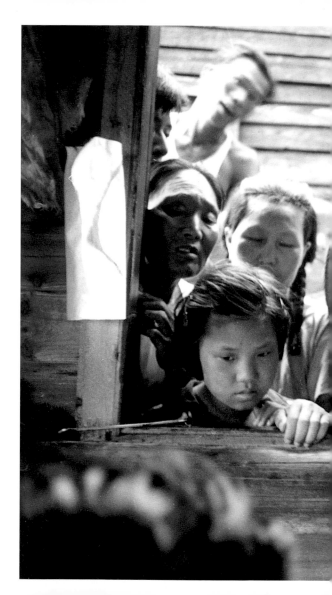

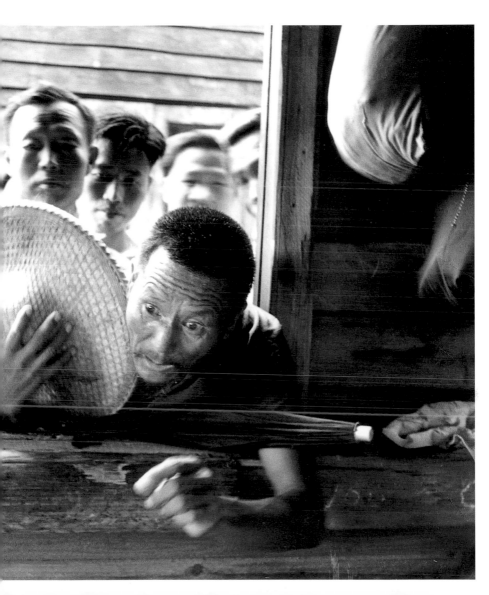

(previous page) Chinese Refugees, Hong Kong, 1952. An anxious man leans through a window to plead for food stamps from an unseen bureaucrat. For many years following Mao Tse-tung's establishment of the People's Republic of China in late 1949, refugees from the Communist regime continued to flow into Hong Kong. The city remained a British colony for another fifty years.

Farmer, Cambodia, 1952. Sheltered under a leafy parasol, this farmer tethers his grazing cattle to his belt. Bischof, who had used lighting and close-ups to show things in a fresh way during his early period, frequently employed a low camera angle during his Asian period to give his viewers a different perspective.

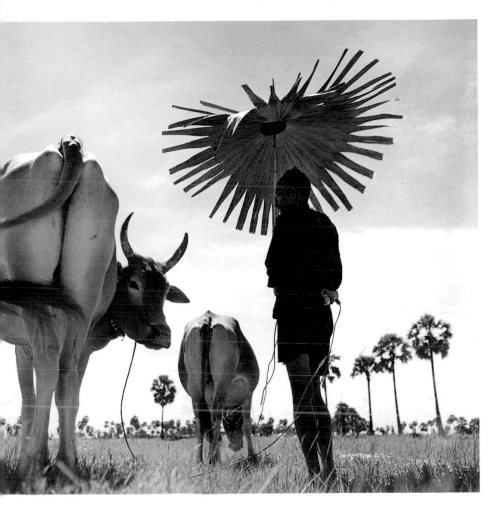

Mother and Child, Hong Kong, 1952. Bischof draws a contrast between a humble mother, pausing in the doorway of an artifacts shop, and the haughty demeanour of the painted warrior behind her.

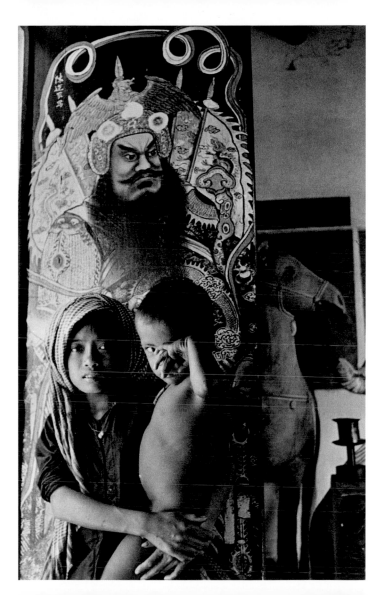

French Soldiers on the Train 'La Rafale', Indochina, 1952. A French soldie[r] sights his target as he prepares to launch a mortar shell. This train, whic[h] passed through contested territory, was regularly attacked by the Viet Minh[.] *Paris Match* assigned Bischof to Indochina to produce pictures that showe[d] the heroism of French troops.

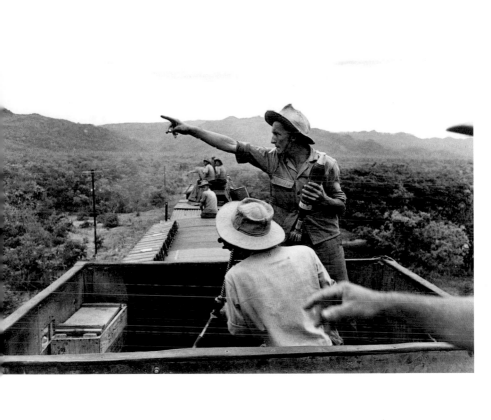

Women Praying for their Men, Indochina, 1952. The contorted body language of this woman expresses the intensity with which she prays for her husband, a soldier with the French forces. In its own way, the photograph makes an anti war statement as strong as the Italian graffito, 'No alla Guerra' (page 41).

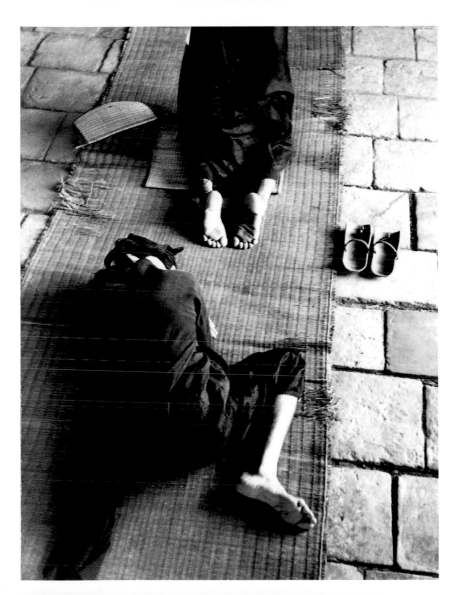

Rice Farmer, Indochina, 1952. A peasant and his water buffalo plough a rice paddy in the Red River Delta in what is now northern Vietnam. Bischof's attraction to such traditional farming methods was due to his interest in people in third-world cultures who were trying to withstand Westernization.

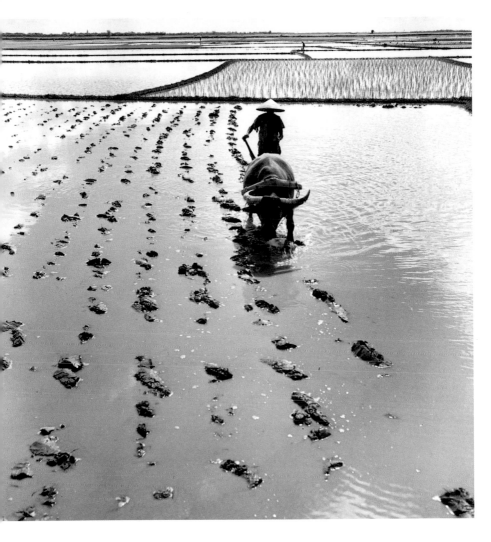

At the Museum in Hanoi, Indochina, 1952. A group of school-aged girl study hand-carved panels depicting scenes from Vietnamese culture. They ar dressed in the traditional ao dai costume. The colour white, which symbolize purity, is reserved for children.

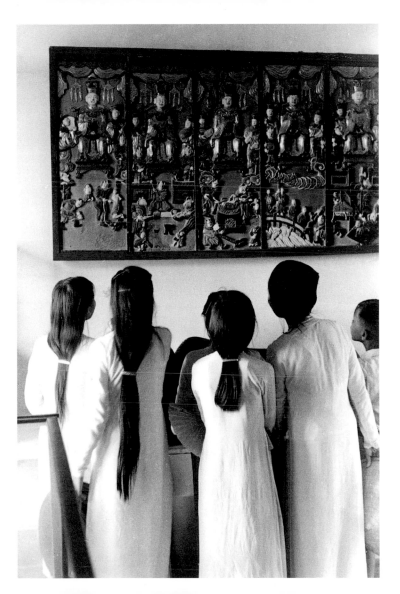

Back from the Market, Barau, Indochina, 1952. Distressed by the fighting, Bischof sought refuge in the Moi village of Barau. It offered him 'an oasis in the midst of the cruel war'. There he found the grand themes of the human condition: 'birth, life, natural death'. The market place was another such theme, and in this picture he captures young women gracefully balancing their empty baskets as they walk home along the railway tracks.

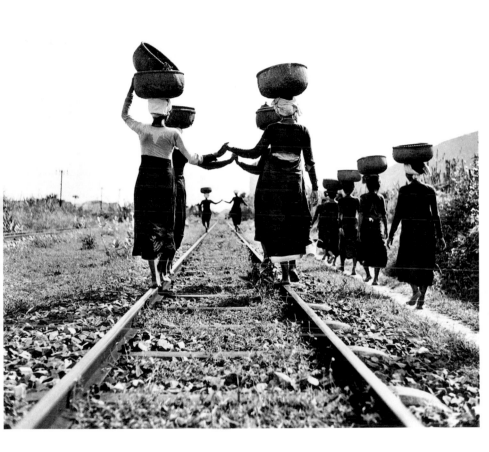

In the Streets, New York City, USA, 1953. Bischof responded to New York with ambivalence, finding it vibrant and exciting, but also harsh and dehumanizing. Here, he reduces a skyscraper to a reflection on the back of a car. During this period, magazines were using more and more colour on inside pages as well as their covers. Frequently Bischof would make the same picture in both black and white and colour. A colour version of this photograph juxtaposes warm orange in the licence plate and yellows and brownish reds in the buildings' reflections against a deep, cold blue in the car's finish.

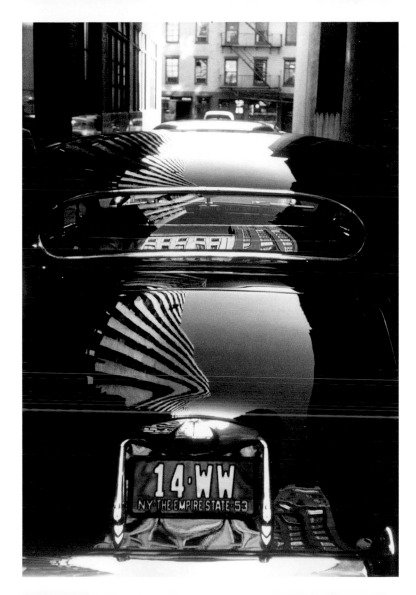

Pedestrian Crossing, New York City, USA, 1953. Three men scurry between car across the rain-dampened pavement of a New York street. Although Bischo humanized people all over the globe, most of his New Yorkers remain anonymou and depersonalized, as in this picture taken from above.

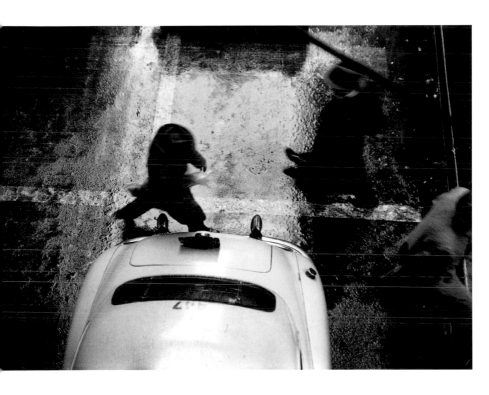

Reflecting Window, New York City, USA, 1953. At least since Atget and the Surrealists who embraced him, photographers have discovered interesting fragmentations and spatial dislocations through photographing plate glass windows. Here Bischof makes the mannequin more substantial than the busy humans who rush past it in a blur.

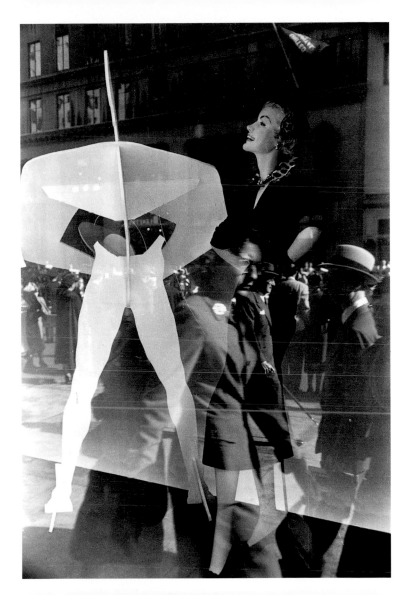

Worker, New York City, USA, 1953. In another comment on New York City, Bischof shows this worker struggling against the reinforcement bars of the wall he is constructing, as if he is hemmed in by them. The skyscraper and the car, twin icons of the modern city, complete this indictment of Western materialism.

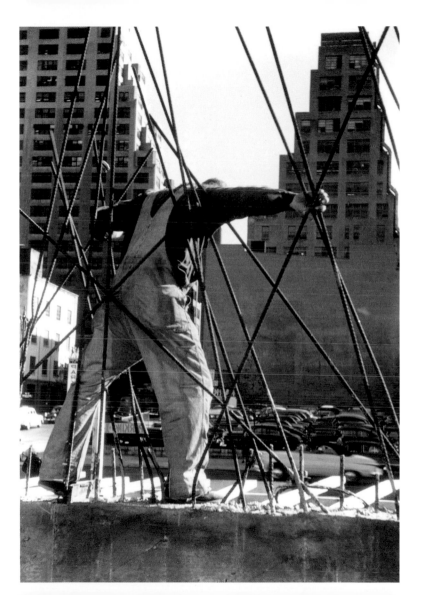

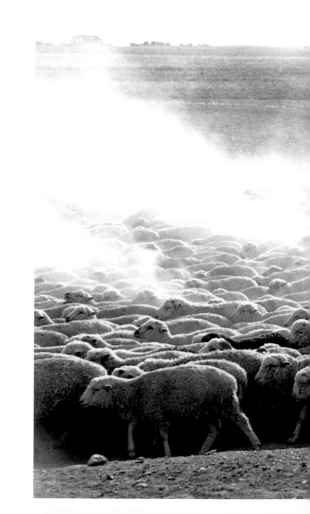

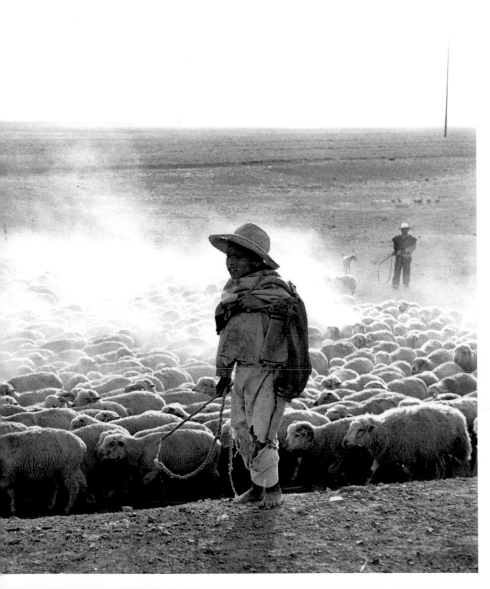

(previous page) Shepherd, Hidalgo State, Mexico, 1954. A barefoot boy minds his dusty flock along a back road in Hidalgo. Bischof found a simplicity and genuineness in Mexico that must have been amplified by such encounters.

Machu Picchu, Peru, 1954. After the depressing neighbourhoods of Lima Bischof was thrilled by the Inca ruins at Machu Picchu, both for their own sake and as a site that offered unlimited possibilities for his camera. In a letter to a friend he described 'the music of the wind, the water, the changing light, and the wall of rain that came up behind the Huayna Picchu like a vast grey sheet'.

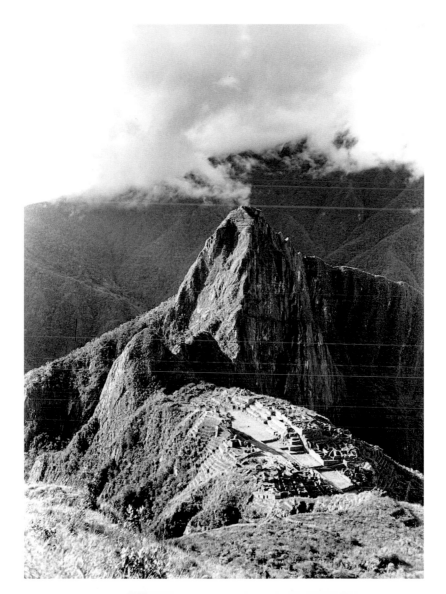

Steps in Machu Picchu, Peru, 1954. 'I walked through the archways over marvellous, rough-hewn steps. Windows, openings revealing ever more intersections and overlaps ... ', Bischof wrote of Machu Picchu. His mastery of lighting and choice of camera angle capture the simplicity and power of the Inca builders' achievement.

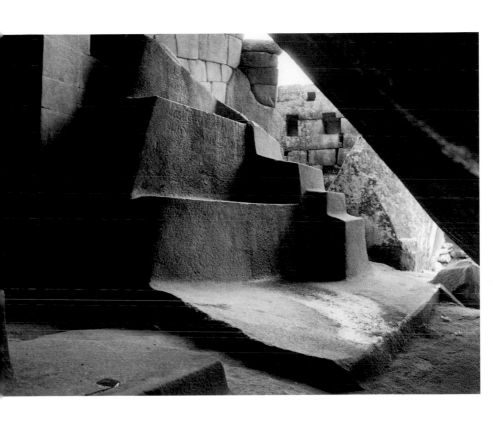

On the Way to Cuzco, Peru, 1954. This solitary flute player evokes another human universal: the compulsion to make music. Seen in contrast to the New York construction worker imprisoned by his work (page 117), this image celebrates the humane authenticity of traditional cultures where people fit comfortably into their natural environment.

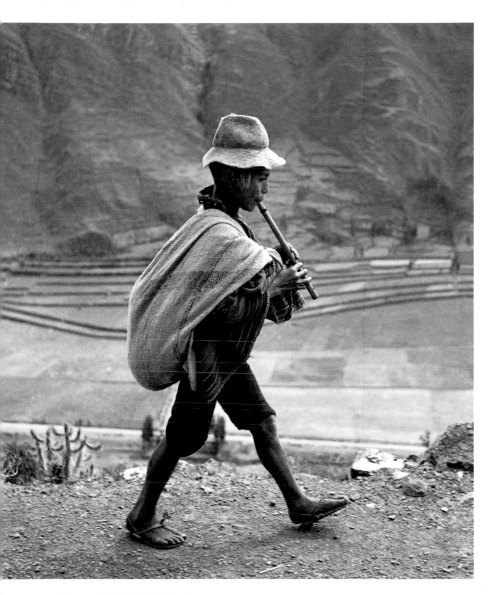

1916 Born 26 April in Zurich, where his father is manager of a pharmaceutical firm.

1931 Bischof's mother dies when he is fifteen years old.

1932 Enrols at the School of Applied Arts, Zurich, where he attends Hans Finsler's newly established photography course.

1936 Receives his diploma from the School of Applied Arts and sets up as an advertising photographer and designer in Zurich.

1938 Works for the publisher Amstutz und Herdeg, producing advertising and fashion photography.

1939 Helps set up the Swiss National Exhibition in Zurich. Moves to Paris to start career as a painter, but outbreak of World War II forces him to return to Switzerland.

1940–1945 Spends 800 days on active duty in the Swiss army.

1942 First publication of photographs in *Du*, magazine founded by Arnold Kübler. Becomes a regular contributor. Member of Allianz, a group of progressive Swiss artists.

1944 Produces first photo-essays, 'The Handicapped' and 'Refugees'.

1945 Sets out to record the aftermath of World War II in France, Germany and Holland.

1946–1948 Photographs are published in *Du*, special issue, May 1946. Photographs in Cologne, Berlin, Leipzig, Dresden. For Schweizer Spende, a Swiss international relief organization, goes first to Austria, Italy, Greece and eastern Europe and then to Finland.

1949 Photographs are published in *Du*, special issue, June 1949. Marries Rösli Mandel, whom he met in Italy. Works in England for *Picture Post*, *Illustrated* and the *Observer*. Joins Magnum, the prestigious photographers' co-operative. Edits the book *Mother and Child*.

1951–1952 Goes to India on assignment for Magnum. In May, works for *Life* magazine on what becomes his best-known story, 'Famine in India'. For Magnum, completes assignments in Korea and Japan. Sent by *Life* to Tokyo. Spends a year in Japan. Also covers war in Indochina for *Paris Match*. Prepares special issue of *Du* and exhibition on 'People of the Far East' in Zurich.

1953 Works in New York on commercial assignments to finance an extensive photographic tour of South America.

1954 In spring, travels to Mexico with Rosellina. Works for Magnum and *Life* on picture stories in Lima, Santiago de Chile and Panama. Visits Cuzco and the Inca city of Machu Picchu. Back in Lima joins a geologist on a trip to the Amazon. On 16 May, Werner Bischof is killed when their car plunges into a gorge in the Andes.

Photography is the visual medium of the modern world. As a means of recording, and as an art form in its own right, it pervades our lives and shapes our perceptions.

55 is a new series of beautifully produced, pocket-sized books that acknowledge and celebrate all styles and all aspects of photography.

Just as Penguin books found a new market for fiction in the 1930s, so, at the start of a new century, Phaidon **55**s, accessible to everyone, will reach a new, visually aware contemporary audience. Each volume of 128 pages focuses on the life's work of an individual master and contains an informative introduction and 55 key works accompanied by extended captions.

As part of an ongoing program, each **55** offers a story of modern life.

Werner Bischof (1916–54) was an outstanding photojournalist of the postwar years. After his beginnings as an advertising photographer, it was the destruction wrought by World War II that led him into photojournalism. His work was motivated by the belief that photography could raise awareness and thereby effect real change and bring about a better world.

Claude Cookman gained a doctorate in the history of photography from Princeton University after working as a journalist for eighteen years. Since 1990 he has taught visual communications at Indiana University.

Phaidon Press Limited
Regent's Wharf
All Saints Street
London N1 9PA

Phaidon Press Inc.
180 Varick Street
New York NY 10014

www.phaidon.com

First published 2001
©2001 Phaidon Press Limited

ISBN 0 7148 4041 6

Designed by Julia Hasting
Printed in Hong Kong

Photographs and quotations from Werner Bischof © Werner Bischof Estate. Selection of photographs by Marco Bischof, Tania Kuhn and René Burri.